An Introduction to
Indian Court Painting

Cover Illustration (See plate 29)

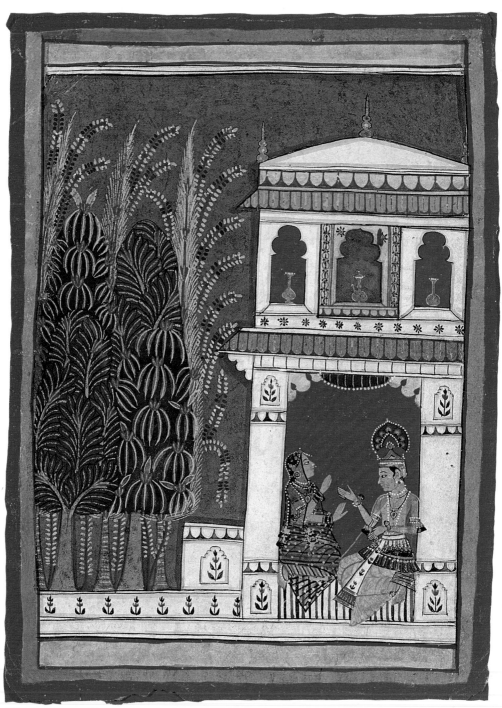

Krishna and a lady in a pavilion. Illustration to
the musical mode *Bhairava raga* Malwa, c.1660
7¾ × 5¾ in (20 × 14.5 cm)
I.S. 55-1952

An Introduction to
Indian Court Painting

Andrew Topsfield

Assistant Keeper, Indian Department
Victoria & Albert Museum

LONDON: HER MAJESTY'S STATIONERY OFFICE

Series Editor Julian Berry
Designed by HMSO/Graphic Design
Printed in the UK for HMSO

ISBN 0 11 290383 5
Dd 718108 C65 9/83

Unless otherwise stated, all paintings are on paper and measurements are of
picture surfaces only, excluding borders.

ACKNOWLEDGEMENTS
I am grateful to Christine Smith and Brenda Norrish for their photographic
work, to Betty Tyers and Graham Parlett for their assistance, and to
Robert Skelton for advice.
Andrew Topsfield

HER MAJESTY'S STATIONERY OFFICE

Government Bookshops

49 High Holborn, London WC1V 6HB
13a Castle Street, Edinburgh EH2 3AR
Brazennose Street, Manchester M60 8AS
Southey House, Wine Street, Bristol BS1 2BQ
258 Broad Street, Birmingham B1 2HE
80 Chichester Street, Belfast BT1 4JY

*Government Publications are also available
through booksellers*

The full range of Museum publications is displayed and sold at
The Victoria & Albert Museum, South Kensington, London SW7 2RL

Introduction

A remarkable flowering of regional schools of painting took place at the Muslim and Hindu courts of northern India and the Deccan between the 16th and 19th centuries. Today this enormous production of pictures and illustrated manuscripts has been largely dispersed by the disinherited princely families and is found in public and private collections throughout the world. Even to modern man, living in a Babel of visual information, the appeal of Indian pictures is immediate. They were made above all to delight the eye by their rich colour harmonies and fluent clarity of line and, by keeping in each case to a traditional range of expressive conventions, to impart mainly auspicious or pleasurable sentiments, whether of royal grandeur, devotional wonder or a refined eroticism. It was an art inseparable from the courtly milieu and its preoccupations both with religious, literary and musical culture and with the self-regarding imagery of power and display.

Except at the Mughal court, where the best of them were unusually honoured, the painters themselves were generally artisans of no special status, hereditary craftsmen who transmitted a continuous tradition which was modified in each generation as a result of their patron's interest – or lack of it – in their work. Stylistic changes can often be related to the personalities of individual rulers, so far as we know them: they are on the whole better recorded by the more historically minded Muslim chroniclers than by the Hindu bards and genealogists.

The medium used by the artists was gouache: mineral, vegetable and animal pigments mixed with gum arabic, often with embellishment in gold and silver, applied to a prepared paper or, more rarely, cloth support. At the Muslim courts the finished work was often mounted within wide paper borders which were ruled and decorated in gold and colour; Rajput pictures tend to have an integral painted border, often a bright lacquer red. The whole picture seldom exceeded a size suitable for holding in the hand. Although Indian paintings are nowadays seen hung uncompromisingly in rows in galleries, they were not intended for wall display. In the palaces their designs were sometimes enlarged – and coarsened – in mural paintings, of which few early examples survive. Paintings on paper

were kept bound in albums or stacked in cloth-wrapped bundles in libraries or store-rooms, from which they would be fetched by command, to be appreciatively inspected at intimate gatherings of nobles or ladies.

An audience of this kind would have understood naturally the pictorial conventions employed by artists of their own and neighbouring courts, and the densely interwoven mythological, poetical and musical allusion implicit in their subject matter. Such resonances could be lost on the modern viewer, who may also be bewildered by the sheer diversity of the regional court styles represented in museum collections, with subjects ranging from naturalistic portraits of rulers and courtiers to farouche depictions of Hindu deities or of the modes of North Indian music (*ragas*) personified as gods, princes and ladies. This diversity reflects above all the differing religious and cultural traditions of the four principal dynastic and regional centres of patronage.

From the late 16th century the most influential of these was the prolific atelier of the Muslim Mughal emperors, who dominated northern India from their courts at Agra, Delhi and Lahore. It was complemented by the distinct traditions maintained by the independent Muslim sultanates of the Deccan until their annexation by the Mughal emperor Aurangzeb in the 1680s. At the same time, a great variety of local styles, influenced by Mughal example but fundamentally indebted to older, indigenous traditions, flourished at the semi-independent Hindu courts of the Rajputs. These formed two geographically separate groups, in Rajasthan and Central India to the south and in the Punjab Hills to the north. If the Rajasthani and Pahari (or 'Hill') schools did not often achieve – or seek – the technical refinement of the best Mughal and Deccani painting, they made up for it both in intensity of feeling and in their greater longevity. Their relative isolation and closeness to folk roots enabled them to survive the political disasters of the 18th century and, in the case of some Rajasthani schools, to continue into the mid-19th century, or even later at a few courts, where the undermining influences of Western art and photography were for a time successfully assimilated or ignored.

Painting Before the Mughal Period

The painting of India's classical civilization (c.500 BC–1000 AD) has been almost entirely destroyed by the climate, pests and later Muslim iconoclasm. Early literary sources describe palaces, houses and temples as being abundantly decorated with wall-paintings. Painting on wood or cloth was also widely practised, and picture-making is one of the sixty-four polite arts enjoined on the cultivated man or woman in the *Kama Sutra* of Vatsyayana. A glimpse of this incalculable loss to world art is offered by the remains of wall-paintings at the Buddhist cave-temples of Ajanta (c.100 BC–500 AD). Their depictions of scenes from the lives of the Buddha evoke an ideal world, peopled by aristocratic and serenely graceful

1
The goddess Tara expounding doctrine to two attendant goddesses
From a palm-leaf manuscript of the *Ashtasahasrika Prajnaparamita*
Pala school, eastern India, c.1118
2 × 2¾ in (5 × 6 cm)
I.S. 8-1958

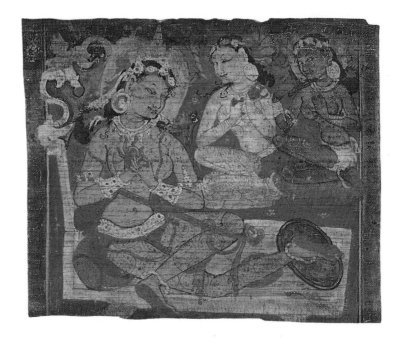

gods, men and women living in harmony with nature. The artists' methods, which included naturalistic techniques of tonal modelling and spatial recession, are recorded in extant manuals (*shilpashastras*).

The later paintings at Ajanta, however, appear to stand at the end of the classical tradition supported by the Gupta and Vakataka dynasties (fourth and fifth centuries). In the following centuries a gradual regression occurred from naturalistic, modelled forms to stylised outline drawing enclosing flat, decorative colour areas. Something of the graceful quality of Ajanta painting still remains in the earliest surviving illustrated palm-leaf manuscripts, produced in the scriptoria of the great Buddhist teaching monasteries of eastern India under the Pala dynasty in the 11th and 12th centuries. Paintings of the Buddhas or of associated deities, either wrathful or benign like the compassionate goddess Tara [plate 1], were introduced into the sublimely metaphysical Buddhist wisdom texts not for illustration but for the protection of the owner and the manuscript.

From the early 13th century northern India was overrun by Turks and Afghans from Central Asia, who established Muslim dominance over all but the far south of the sub-continent. With the destruction of the monasteries, Buddhist culture all but disappeared in its homeland, and the Pala tradition was carried on only in Nepal and Tibet. Hindu religious and secular culture also suffered from the removal of royal patronage. The culture of the Muslim sultans was Persian, and their taste in painting extended only to manuscript illustration in Persianate styles. During these lean early centuries of Muslim rule, the native tradition of painting was largely kept alive by members of the wealthy merchant classes of western India who were devotees of Jainism, an ascetically inclined religion founded by Mahavira, a near-contemporary of the Buddha, in the 6th century BC. Prosperous Jain laymen commonly sought religious merit by commissioning illustrated copies of sacred texts for presentation to monastic libraries. Huge numbers of stereotyped and sometimes gaudily opulent series of illustrations were thus produced.

The regression towards a linear, conceptual mode of representation was now complete. One of the characteristic features of the style is the protrusion into space of the further eye of the human face seen in profile. Nevertheless, their wiry drawing, simplified colour schemes and profuse detail can give Jain paintings an energy and charm of their own [plate 2]. The schematic and literal-minded approach of the artists to their subject matter is seen in a lively illustration, divided into upper and lower registers, of the ideally chaste monk, who is unmoved by the beguilements of women [plate 3].

Jain patronage thus preserved intact elements of a native style, which were by the early 16th century to be revivified by artists working in a new and more expressive idiom. During the 15th century a resurgence of popular Hindu devotional cults had occurred throughout northern India, centred on the incarnations of Vishnu as

the hero Rama and, more particularly, as Krishna, the youthful, dark-skinned cowherd god. Krishna's mythical exploits during his childhood and youth spent in a village in the Braj country near Mathura included the slaying of many demons and a tyrant king as well as various love sports with the local milkmaids, among whom Radha became a pre-eminent figure. These episodes were celebrated in devotional verse in the Sanskrit and vernacular literatures, and they also came to be represented in a vigorous, widespread style of manuscript illustration. The patrons of this new development appear to have been both the Vaishnavite merchant classes of the Mathura region and, at a more refined level of production, the still independent Hindu courts of the Rajputs, who had resisted Muslim incursions and continued to rule the adjoining regions of Rajasthan and Central India. A page from the most lively and inventive of the surviving manuscripts in the style [plate 4] shows an enhanced spatial sense and fluency of drawing and a use of glowing colour to create an atmosphere of elation appropriate to its subject: Krishna's parents are shown standing before the sacrificial fire, on which the priest who is marrying them pours ghee, while female attendants and male guests look on.

As patrons of learning, literature, music and art, the Rajput rulers also preserved and developed the secular traditions of classical Indian culture. Manuscript illustrations of poetical texts were produced in the same style as the devotional themes, and the two streams were in fact largely indistinguishable. Down to the 19th century, Krishna subjects in particular became closely associated with the imagery of poetical and rhetorical works. Displaying the Indian passion for minute classification, these enumerated the many different types of male and female lovers and their emotional states, or, in the case of *ragamala* texts, evoked the essential character of the *ragas* or musical modes in images of gods, ascetics, nobles, ladies and animals in specific attitudes and configurations. In one of the earliest surviving *ragamala* pictures [plate 5] the mode *Bhairavi* is described in the verses above as a lady of fair complexion who worships Shiva in his *lingam* (phallic) form with flowers, songs and cymbal accompaniment at a lakeside temple near the sacred Mount Kailasa. As so often in Rajput pictures, there is a mingling of the devotional and erotic sentiments, hinted at by the temple finial in the form of a flag-bearing *makara*, a mythical aquatic beast emblematic of the love-god Kama. In its allusive subject matter, bold drawing and juxtaposition of broad areas of pure colour, this style of painting anticipates the later work of the Rajasthani and Central Indian schools, whose individual histories only begin to be clear from the early 17th century onwards. However, their continuity from the earlier style is difficult to trace precisely, for from the late 16th century Rajput patronage was both disrupted and modified by the coming of the Mughals, the last and most powerful of the Muslim dynasties of northern India.

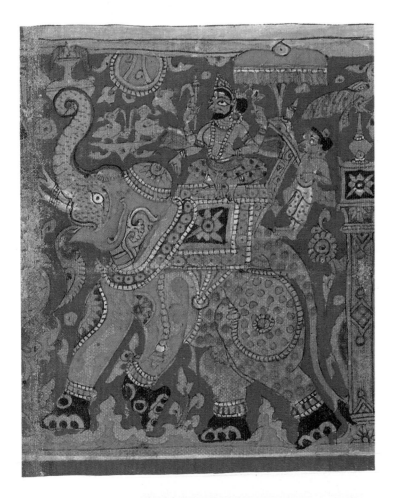

2
An elephant and royal rider
A detail from the painted border
of a Jain *yantra* (mystical
diagram) on cloth
Gujarat, 1447
Detail approx. 4¼ × 3¼ in
(10.5 × 8.5 cm)
I.M. 89-1936

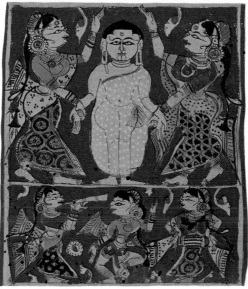

3
The chaste monk avoids the lures
of women
From a manuscript of the
Uttaradhyayana Sutra
Cambay, Gujarat, c.1450
4½ × 4 in (11.2 × 10 cm)
I.S. 2-1972, f.16b

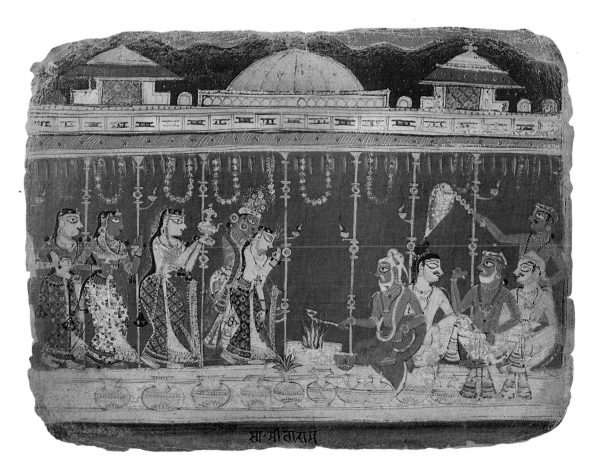

4
The marriage of Krishna's parents
From a dispersed manuscript of
the *Bhagavata Purana*
Rajasthan (?), c.1525–50
6¾ × 9¼ in (17.5 × 23.8 cm)
I.S. 1-1977

5
A lady worshipping the *lingam*
An illustration to the musical
mode *Bhairavi ragini*
Rajasthan (?), c.1525–50
$8\frac{1}{2} \times 6\frac{1}{2}$ in (21.3 × 16 cm)
I.S. 110-1955

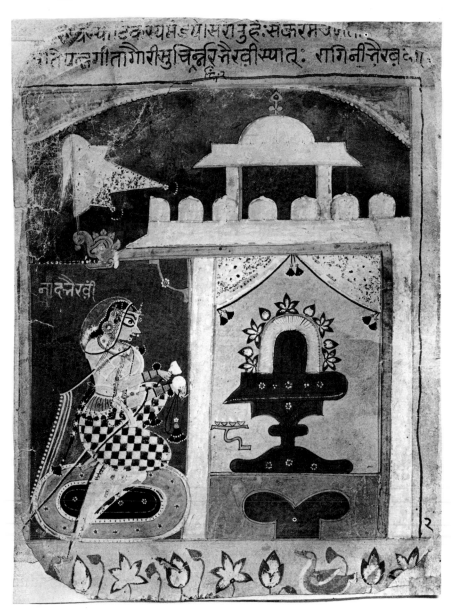

The Mughal School

In 1526 Babur, a minor prince from Transoxiana descended from both Tamerlane and Chingiz Khan, culminated a lifetime of restless wanderings and short-lived conquests by invading India. He founded a dynasty whose autocratic power and luxurious display became proverbial as far away as England. Although its decline was to be lengthy, it endured in name at least until the banishment of the last Emperor by the British in 1858. For much of this period the cultural interests and fashions of the imperial court exercised a pervasive influence throughout the provinces, and not least on the art of painting.

Babur himself died in 1530, soon after his conquest. He is not known to have patronised painting during his turbulent career, but he did leave behind a remarkable volume of memoirs, whose observations of man and nature reveal an original and inquiring mind. During the reign of his bookish and ineffectual son Humayun (1530–56) the still insecure empire was lost for a time to the Pathan chief Sher Shah. Humayun was driven into exile at the court of Shah Tahmasp of Persia, who, after a carefree youth distinguished by inspired artistic patronage, was turning towards religious orthodoxy and a greater attention to matters of state. Humayun was thus able to take two of the finest Persian painters, Mir Sayyid Ali and Abd us-Samad, into his service. They accompanied him on his return to Delhi in 1555, where he died only a few months later after a fall on his library staircase.

The achievement of consolidating the empire and shaping its distinctive cultural traditions belonged to Akbar (1556–1605), the third and greatest of the Mughal emperors. He possessed not only the mental acuteness of Babur but an all-embracing imperial vision and colossal physical energy with which to fulfil it. By arms and diplomacy he extended the empire and made allies of the powerful Rajputs. More than any earlier Muslim ruler, he had a receptive and tolerant intellect. Many of his generals, courtiers, wives, poets and artists were Hindus. His strong religious experiences led him to an open-minded debate with representatives of all the known faiths, including Zoroastrians, Jews and Jesuit priests. Disappointed by the animosity of these clerics, he typically chose to found an eclectic and short-lived religion centred on his own person.

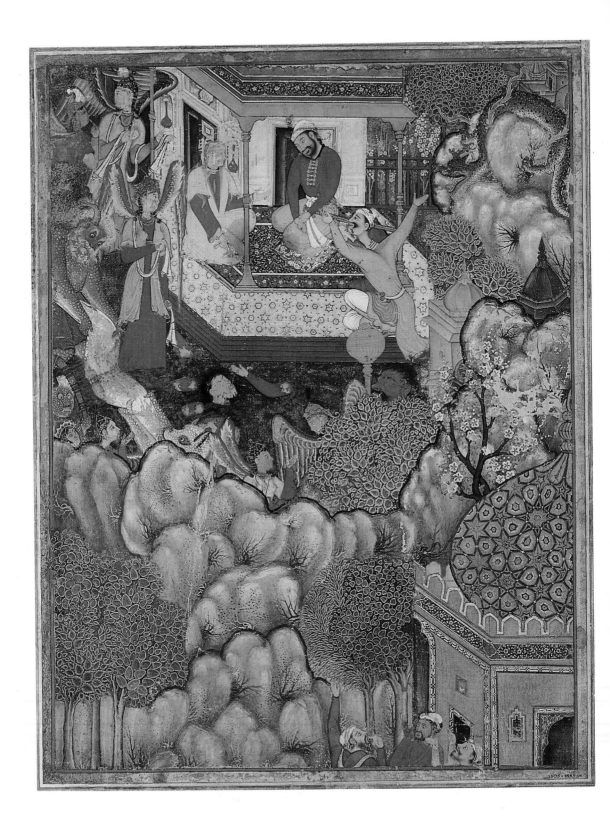

6
The fairies call on Hamza to slay
a dragon troubling the *jinn* of the
Caucasus mountains
From a series of *Hamzanama*
illustrations on cloth
Mughal, c.1562–77
26½ × 20¼ in (68 × 51.5 cm)
I.S. 1505-1883

7
Akbar directs the siege of
Ranthambor in 1569
From a manuscript of the
Akbarnama
By Khem Karan, Mughal,
c.1590
14¾ × 9¾ in (37.5 × 25cm)
I.S. 2-1896 (73/117)

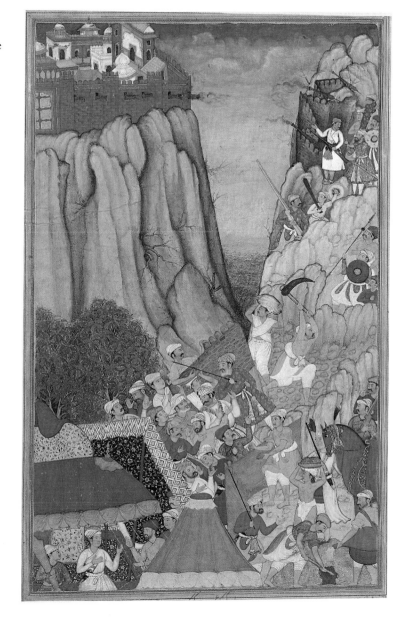

Painting at Akbar's court reflected a similar forcible and dynamic synthesis between the disparate cultures of Persia, India and Europe. Akbar had himself received training from his father's two Persian masters, but the delicate refinement of the Safavid manner did not satisfy his youthful exuberance. Early in his reign he set the two Persians to direct a newly recruited studio that grew to some two hundred native artists. Under his constant supervision the early Mughal style was thus formed from the fusion of Persian elegance

15

and technique with the Indian vitality and feeling for natural forms admired by Akbar. The studio's most grandiose project, taking fifteen years to complete, was a series of 1400 large illustrations on cloth to the romance of Amir Hamza, a prolix but action-packed adventure story which was a favourite of the young Akbar. According to one Mughal historian he would himself act as a storyteller, narrating Hamza's adventures to the inmates of his *zenana* (harem). In a typical page [plate 6], the decorative Persian tile patterns and arabesques stand in contrast to the vigorously painted trees, rocks, gesticulating figures and gory victims of the leering dragon.

By the time of the *Hamzanama*'s completion in the late 1570s, the Akbari style was reaching its maturity. A stream of smaller and less copiously illustrated manuscripts of Persian prose and verse classics was produced in a blander but more integrated idiom. In the last twenty years of Akbar's reign his interest turned to illustrated histories of his own life and those of his Timurid ancestors. At least five copies of Babur's memoirs were made, as well as three of the *Akbarnama*, Abu'l Fazl's official history of his reign. As unequivocal propaganda, these and other commissions formed part of his imperial design, for they documented and legitimised what was in Indian terms still only a parvenu dynasty. The artists were more than ever required to record the court life around them in a spirit of dramatic realism. It is unlikely that the painter Khem Karan would have witnessed the siege of the Rajput fortress of Ranthambor some twenty years previously [plate 7], but his portrayal of Akbar, dressed in white, directing the attack from a promontory set against a hazy sky is a convincing presentation of the event. That this realism was to some extent based on a selective study of European models is shown by an illustration to the *Harivamsa* [plate 8], one of the Hindu mythological texts which Akbar had ordered Badauni to translate into Persian, to that scholar's pious disgust. Krishna sweeps down on the bird Garuda to triumph over Indra on his elephant, watched by gods and celestial beings. The billowing clouds and swirling draperies have Baroque antecedents, while the coastal landscape with a European boat derives from Flemish art. Abu'l Fazl, besides echoing his master's praise of Hindu artists, whose 'pictures surpass our conception of things', refers also to 'the wonderful works of the European painters, who have attained world-wide fame'. He moreover tells us of an album prepared for Akbar which contained portraits of himself and his courtiers. This was the first time in Indian art that portraiture of the Western type, treating its subject as an individual character rather than as a socially or poetically determined type, had been so systematically pursued.

In the reign of Jahangir (1605–27) the imperial studio was reduced to an élite group of the best painters, who attended the Emperor both in court and camp to carry out his commissions. Manuscript illustration gave way to the production of fine individual pictures,

Krishna's combat with Indra
From a dispersed manuscript of
the *Harivamsa*
Mughal, c.1590
$11\frac{1}{2} \times 7\frac{1}{4}$ in (29.5 × 18.3 cm)
I.S. 5-1970

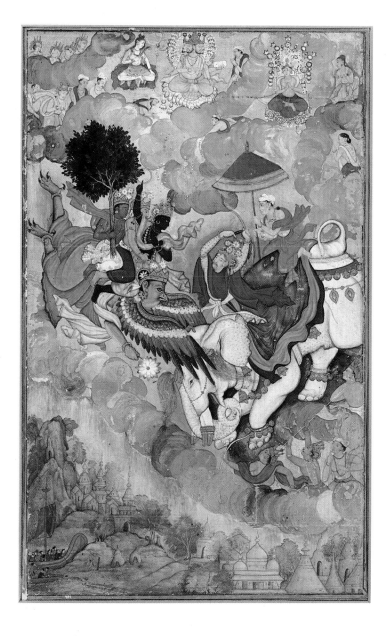

whose subject matter reflected Jahangir's enthusiasms and foibles. Jahangir was a fickle character, capable both of generosity and cruelty. Inheriting a well established empire, he never developed Akbar's gifts as a statesman, and as his prodigious consumption of opium and alcohol gradually enfeebled him, the administration passed out of his hands. He also lacked Akbar's profound religious sense, being guided instead by a highly developed aestheticism. As a connoisseur of the arts, he boasts justifiably in his memoirs of his ability to distinguish even tiny details painted by different artists. He was also passionately curious about the forms and behaviour

of plants and animals, and it has been remarked that he might have been a better and happier man as the head of a natural history museum. When in 1612 a turkey cock was brought in a consignment of rarities purchased from the Portuguese in Goa, Jahangir as usual wrote up his observations, being particularly fascinated by its head and neck: 'like a chameleon it constantly changes colour'. His flower and animal artist, Mansur, known as 'Wonder of the Age', recorded the new specimen [plate 9], rendering each feather and fold of skin with minute brushwork, against a plain background relieved only by (discoloured) streaks and a conventional row of flowers.

The same qualities of dispassionate delineation and static, pattern-making composition informed the now dominant art of portraiture. Jahangir was proud of his artists' ability to emulate the technique of the English miniatures shown to him by the ambassador Sir Thomas Roe, and was delighted when Roe was at first unable to distinguish between an original miniature and several Mughal copies. The effect on Mughal painting was both refining and somewhat chilling. A scene of Jahangir receiving his son Parviz and courtiers in durbar [plate 10] has been skilfully assembled from individual portrait studies and stock pictorial elements such as the fountain, the simplified palace architecture, the cypress and flowering cherry and the Flemish-inspired landscape. In this deliberate compilation there is none of the movement and interaction of figures of Akbari painting. Each finely portrayed face gazes forward in expressionless isolation – an attitude which is, however, appropriate for the solemn formality of the durbar. The painting can be attributed to Manohar, the son of the great Akbari artist Basawan, who had developed a vigorous modelling technique and sense of space from European sources. In deference to Jahangir's taste, these skills were modified by his son, who presents the outward show of imperial life, crystallized in elegant patterns and richly detailed surfaces.

Court portraiture under Shah Jahan (1627–58), exemplified by the *Padshahnama*, the illustrated history of his reign now at Windsor Castle, became still more formal and frigid. Each durbar, battle or procession is a grand compilation of countless individual portraits, painted with a hard, immaculate finish. The effect is magnificent but heartless and strangely unanimated. Shah Jahan's real passion was for jewels and architecture: on these he lavished much of the wealth of the empire, combining them above all in the justly celebrated Taj Mahal. Album paintings of varied subjects were, however, still produced, such as a genre scene of an informal musical party by Bichitr [plate 11], an artist best known for his accomplished portraiture and cool palette. The painting is in fact an exercise in the style of Govardhan, another Hindu and one of the most gifted of all Mughal painters, excelling at keenly observed group portraits of common people – and particularly of holy men – as well as kings.

9
A turkey cock
By Mansur, Mughal, c.1612
5¼ × 5 in (12.8 × 12.2 cm)
I.M. 135-1921

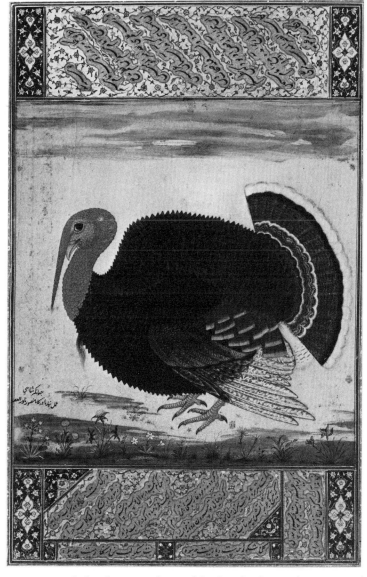

In 1658 Shah Jahan was deposed by his third son, the pious and puritanical Aurangzeb, and Dara Shikuh, the more free-thinking and artistically inclined heir apparent, was put to death. During his long reign (1658–1707) Aurangzeb further dissipated the empire's resources, not like his father by immoderate luxury and building projects, but by interminable military campaigns in the Deccan. The court arts languished for want of patronage, and from 1680 onwards many painters took service at provincial courts. Aurangzeb was followed in the 18th century by a succession of effete incompetents who maintained an illusory show of power while the empire broke up. The sybaritic Muhammad Shah (1719–48), who when told of some defeat would console himself by contemplating his gardens,

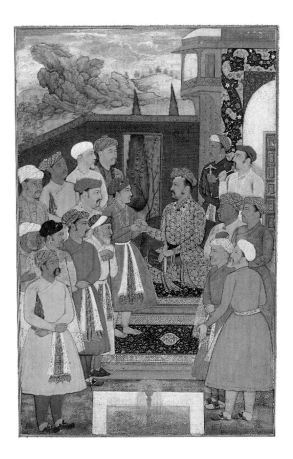

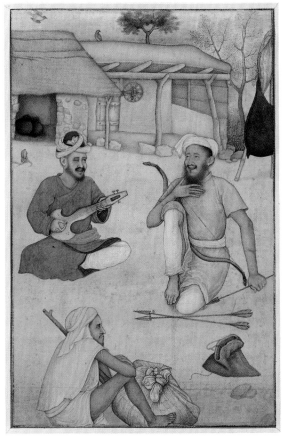

was typical of the age. In 1739 he endured the humiliating sack of Delhi by Nadir Shah of Persia. A nautch (dancing-party) scene in his *zenana* [plate 12] shows signs of the brittle rigidity and vapid sensuality of late Mughal painting, which preserved much of the technique of the mid-17th century style, but had little new to say. The emperors after Akbar had insulated themselves within the increasingly formal and introverted microcosm of court life. Given inspired patronage, painting had for a time flourished in this hot-house atmosphere, but when the empire was played out it too gradually declined into a repetition of well worn themes, both at Delhi and at the provincial courts of Lucknow and Murshidabad. After Clive's victory in Bengal in 1757, British power began to spread across northern India, and by the early 19th century Delhi artists were emulating the style of painting favoured by the new imperialists. A nautch party of this period is set in a European mansion with classical columns and pediments [plate 13]. The figures also are in the Europeanised 'Company' style, but the Indian artist has, resourcefully as ever, transformed the alien conventions of modelling and recession into his own umistakable idiom.

10
Jahangir receives Prince Parviz in audience
Attributed to Manohar, Mughal, c.1610–14
9½ × 6¼ in (23.7 × 15.7 cm)
I.M. 9-1925

11
An archer, a *dhobi* and a one-eyed musician
By Bichitr, Mughal, c.1630–40
7½ × 4¾ in (18.7 × 12.1 cm)
I.M. 27-1925

12
The young Emperor Muhammad
Shah at a nautch performance
Mughal, c.1725
$14\frac{1}{4} \times 11\frac{3}{4}$ in $(36.2 \times 30.4$ cm$)$
I.S. 133-1964, f.64b

13
A nautch party performing in a
European mansion
Delhi, c.1820
$11\frac{1}{4} \times 14\frac{1}{4}$ in $(28.5 \times 36.2$ cm$)$
I.S. 9-1955

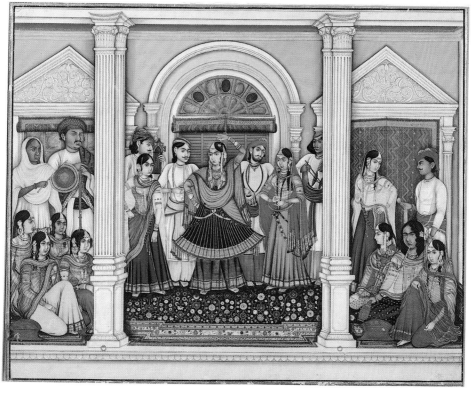

Painting in the Deccan

Painting at the Deccani courts grew from a hybrid cultural background comparable to that of the Mughal school, but with quite different and regrettably short-lived results. By the 16th century five Muslim sultanates had emerged in the Deccan, which, acting together for the only time in their history, disposed of the Hindu kingdom of Vijayanagar in 1565. Afterwards they constantly formed factions and went to war in an almost frivolous manner. Unlike the Mughals, the Sultans failed to take the business of statecraft and territorial domination seriously. They put more passion into the pursuit of courtly pleasures and the patronage of music, literature and the arts. These projects benefited from a rich cultural mixture of Hindu court traditions inherited from the Vijayanagar empire with those introduced by the many Middle Eastern immigrants – Persians, Arabs, Turks and Africans – who had been attracted by the wealth of the Deccani kingdoms. Some European influence was also present, but it was less conspicuous than in Mughal art. The period of greatest achievement lasted only a few decades, for the empire-building Mughals found little difficulty in subjugating the Deccani rulers. Of the three courts known to have patronised painting, Ahmadnagar fell in 1600, while Bijapur and Golconda were finally taken by Aurangzeb in 1686–7.

Those early Deccani paintings which survive are now scattered in many collections. Though few in number, they are remarkably consistent in quality, combining a high degree of finish with a playful refinement of line and subtle richness of palette. Portraits of rulers lack the sober, documentary realism or portentous imperial symbolism of their Mughal counterparts. They are imbued instead with a mood of indolent enjoyment, a conscious and self-absorbed appreciation of the passing moment. The most outstanding single patron was Ibrahim Adil Shah of Bijapur (1579–1627), who is seen in plate 14 seated with a lady in a palace chamber in a delicate (though somewhat later) grisaille study embellished with gold and colouring. Ibrahim was above all things a *rasika*, a Sanskrit term for the man of highly developed sensibility, one who is cognisant of the *rasas* (literally, 'juice' or 'essence'), the sublimated emotional states on which Indian aesthetics are based: they can be approxi-

14
Ibrahim Adil Shah with a lady
Bijapur, mid-17th century after
an original of c.1610
$4\frac{1}{2} \times 3\frac{1}{2}$ in (10.5 × 9 cm)
I.S. 48-1956, f.1b

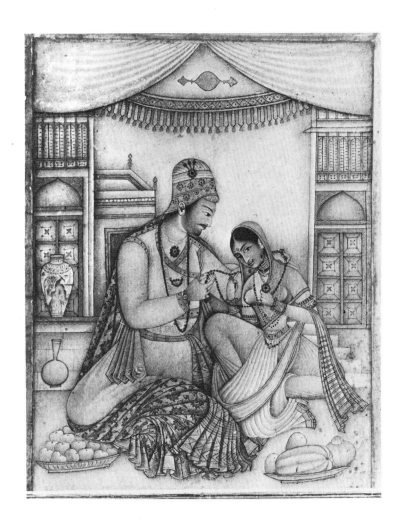

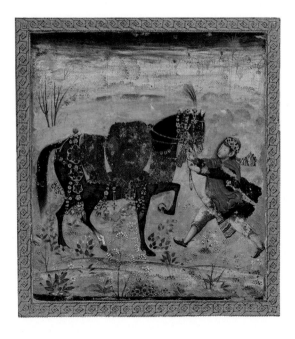

15
A horse and groom
Bijapur, c.1605
$4\frac{3}{4} \times 4\frac{1}{4}$ in (11.2×10.4 cm)
I.S. 88-1965

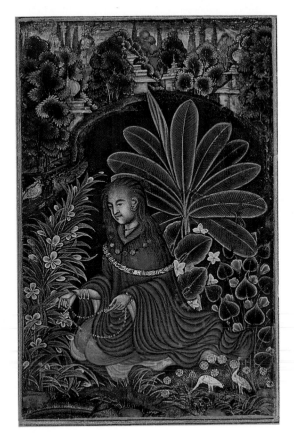

16
A *yogini* seated beside a stream
Bijapur, c.1640, after an original
of c.1605
$4\frac{1}{2} \times 2\frac{3}{4}$ in (11×7 cm)
I.S. 133-1964, f.56a

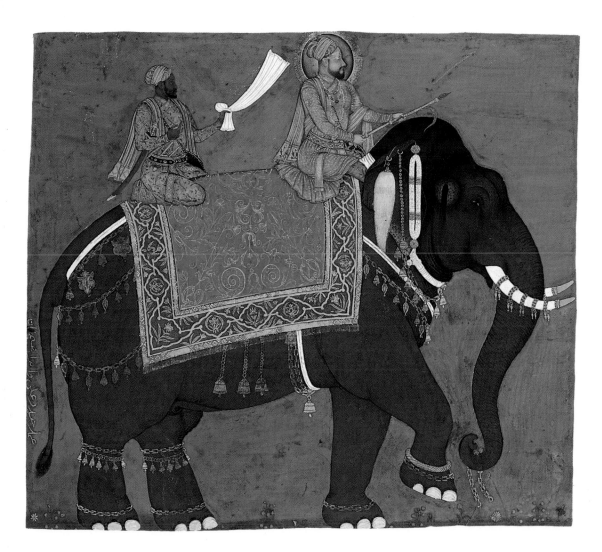

17
Muhammad Adil Shah and his
minister Ikhlas Khan riding an
elephant
By Haidar Ali and Ibrahim
Khan, Bijapur, c.1650
10¼ × 12 in (26.7 × 30.5 cm)

mately translated as love, heroism, disgust, rage, terror, joy, compassion, wonder and peace. He composed a book of lyrics, the *Kitab-i Nauras* (Book of the Nine Rasas), which contains invocations both to the Hindu deities Sarasvati and Ganesha and a Muslim saint, as well as to his favourite elephant and the beloved lute, named Moti Khan, with which he would accompany his singing. He was a master of the slow and dignified *dhrupad* vocal style, and generous provision was made for the thousands of court musicians in his new city of Nauraspur (City of the Nine Rasas). Besides fine elephants, he had a weakness for jewels and mangoes (a plate of them appears beside him here) and he enjoyed taming falcons and parrots. He is said to have written a treatise on chess describing various new and baffling moves, but he did not excel as a statesman or general.

A study of a richly caparisoned horse held by a groom, whose costume shows some European influence [plate 15], is the work of one of Ibrahim's leading painters. Its freshness of colouring is set off by the use of gold, and the trees and plants are suggested by a deftly attenuated line and delicate stippling. A painting of a female ascetic seated by a stream [plate 16], although it is another later and less fine version of an original work of Ibrahim's period, displays the lush landscape conventions and compact density of composition of Bijapur painting.

In 1636 Bijapur was compelled to accept Mughal suzerainty. Lavish exchanges of presents always accompanied political relations between states, and paintings as well as elephants, jewels and money travelled in both directions. The fully developed Mughal style of portraiture inevitably began to influence contemporary work at Bijapur and Golconda. Even so, its naturalistic conventions were often interpreted with subtlety and splendour by the southern artists. A portrait of Muhammad Adil Shah (1627–56) riding an elephant, accompanied by his minister who fans him [plate 17], is derived from a Mughal model, as seen for example in a brush-drawing of a Mughal prince riding the elephant Mahabir Deb [plate 18]; as it happens, the inscription in Shah Jahan's hand records that this elephant was presented to him as tribute by Muhammad Adil Shah. While the Mughal artist has meticulously emphasized the finely textured wrinkles and mottling of the elephant's skin, the two Deccani painters have set its smoky dark mass against a vivid blue ground, throwing into relief the sumptuous textile patterns and the Sultan's gold coat, which has been minutely pricked to catch the light.

From the 1650s the Bijapur and Golconda artists lost their earlier inspiration, and their work declined into more insipid versions of Mughal themes. Aurangzeb's conquest finally disrupted their traditions. In the 18th century, however, as Mughal control of the provinces weakened, the viceroy Asaf Jah was able to establish an independent dynasty based at Hyderabad, near Golconda. Painting began to flourish there in a style which mixed the romantic flavour

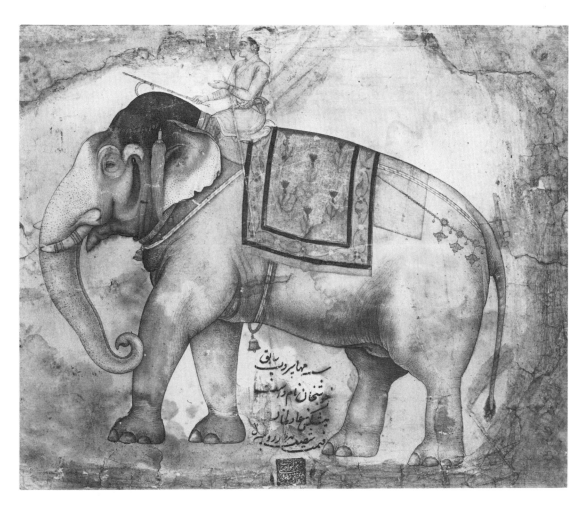

18
A Mughal prince (perhaps
modelled on the young Dara
Shikuh) riding the elephant
Mahabir Deb
Mughal, c.1645
$12\frac{1}{4} \times 14\frac{1}{2}$ in (31×37 cm)
I.M. 23-1928

of the former Golconda school with an increasing Mughal pallor
and rigidity. Nevertheless, a portrait of a Hyderabad minister
[plate 19] retains considerable delicacy of composition and detail.
Versions of the Hyderabad style were widely patronised. A painting
from the Maratha court at Tanjore in the far south is one of the last
in a long line of Deccani procession scenes [plate 20]. Raja Tuljaji
(1765–87) appears as always in profile, wearing a flowered gold coat
and riding a frisky horse; but his retainers already show the influence
of the Company style. Within a few years his adopted son Sarabhoji,
who had been tutored by the Danish missionary Swartz, would be
patronising natural history painting of the European type.

19
The minister Munir al-Mulk
Aristu Jah with attendants
Hyderabad, c.1810
13 × 10 in (32.7 × 25.3 cm)
I.S. 163-1952

20
Raja Tuljaji riding in procession
Tanjore, c.1780
29¾ × 21¾ in (75.5 × 55.5 cm)
I.M. 319-1921

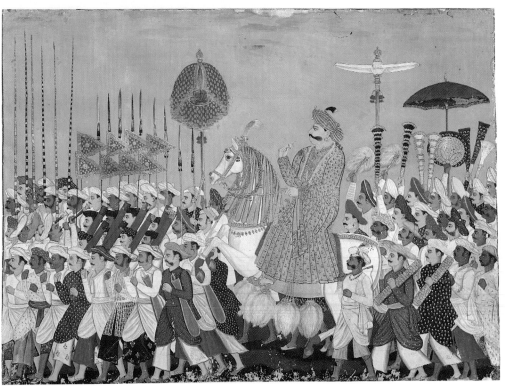

Rajput Painting in Rajasthan and Central India

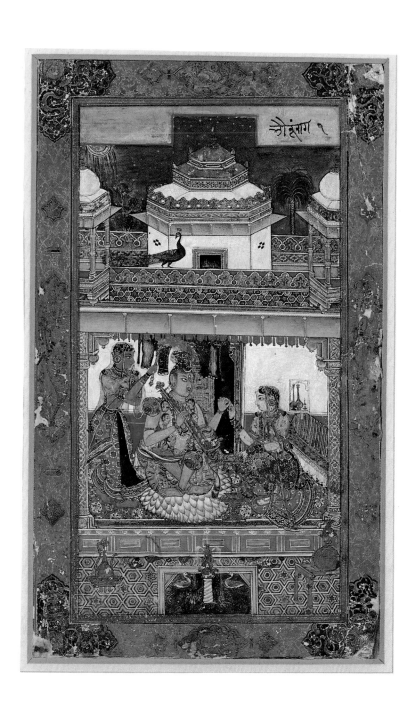

21
Shiva with female attendants.
Illustration to the musical mode
Bhairava raga
From a *ragamala* series painted at
Chunar, 1591
10 × 6 in (25.2 × 15.1 cm)
I.S. 40-1981

By the 1570s Akbar had succeeded in subduing nearly all the major Rajput kingdoms and in winning over their rulers by giving them command of his armies and marrying into their families: his chief queen and Jahangir's mother was a Rajput princess from Amber. Spending long periods at the imperial court, the rajas and their sons naturally began to imitate its customs and fashions. From around 1600 some of them employed artists trained in the Mughal studio, who worked in a hybrid style of Hindu manuscript illustration which is usually called Popular Mughal. Later in the 17th century some of the rajas were able to employ more accomplished artists, skilled in the portrait styles of the Jahangir and Shah Jahan periods. These and subsequent waves of Mughal influence had varying but sometimes profound effects on the local schools of Rajasthan and

22
A lady with blackbuck.
Illustration to the musical mode
Kakubha ragini
Amber (?), c.1680
11 × 7¾ in (28 × 19.7 cm)
I.S. 85-1952

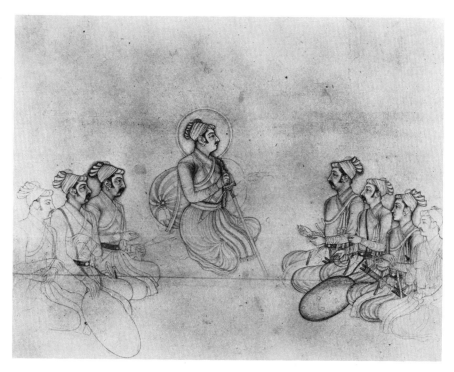

23
Maharaja Jaswant Singh seated in
durbar
Jodphur, c.1660
6½ × 8½ in (16.5 × 21.5 cm)
I.S. 559-1952

24
An elephant fight
Kotah, c.1700
12¾ × 26¾ in (33 × 67 cm)

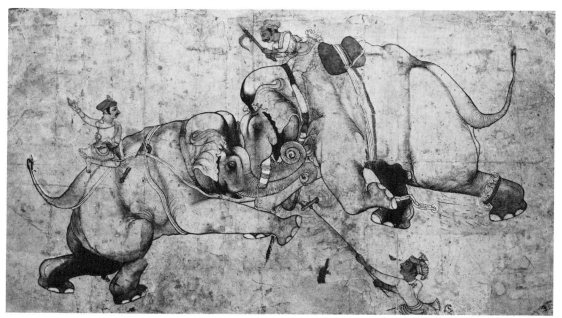

Central India, each of which assimilated the new conventions in differing degrees to their existing traditions, as represented for example by *Bhairavi ragini* [plate 5].

The closest continuation of the pre-Mughal style appears in the boldly simplified designs and colour schemes used in the schools of Malwa and Bundelkhand. In a typical *ragamala* picture [opposite the title page], *Bhairava raga* is depicted in the form of Krishna conversing with a lady in a pavilion flanked by stylised flowering trees. The primitive expressive power of this style is scarcely affected by the Popular Mughal influence that was reaching the Rajasthani

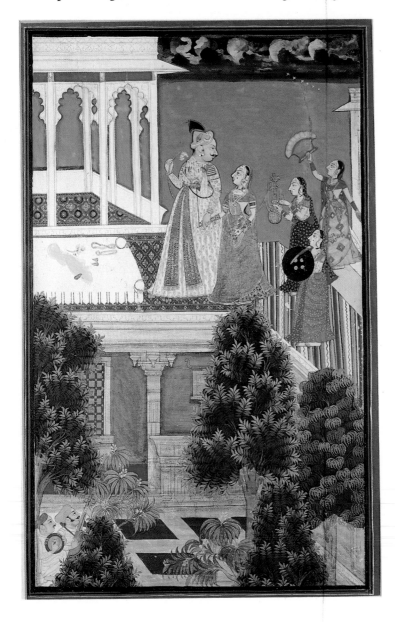

25
A nobleman, probably Baba Bakhat Singh, with ladies
Udaipur, c.1740–50
15¾ × 9¾ in (40 × 25 cm)
I.S. 117-1954

courts. It may be contrasted with a version of the same subject [plate 21], in this case more correctly conceived as Shiva (of whom Bhairava, 'the Terrible', is an epithet), who sits under a flayed elephant skin in a royal palace attended by maids. This picture belongs to a series painted at Chunar, near Benares, in 1591 by artists trained in Akbar's studio. Its judicious use of figural modelling and spatial recession as well as the decorative tile-work and arabesque borders of the painting are all Akbari features. The series must have belonged at an early date to the rulers of Bundi, whose imperial service brought them at one stage to Chunar, for its iconography established

26
Radha offering betel (*pan*) to
Krishna in a grove
Kishangarh, c.1760
9¼ × 5¾ in (23.5 × 14.5 cm)
I.S. 40-1980

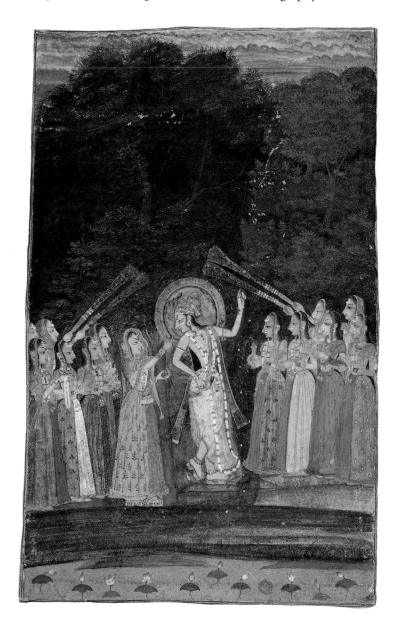

a norm for later Bundi *ragamalas*. At other courts manuscript illustration was similarly modified by a more dilute Popular Mughal influence. A version of *Kakubha ragini*, personified as a lovelorn lady whose charms pacify the wild blackbuck [plate 22], is composed in an archaic series of registers and combines old-fashioned landscape conventions with elegantly attenuated figure drawing and a row of stylised Mughal flowers at the top.

During the second half of the 17th century portraiture and genre scenes of the Mughal type were introduced at all the main courts, with varying degrees of adaptation to the Rajput vision. Jaswant

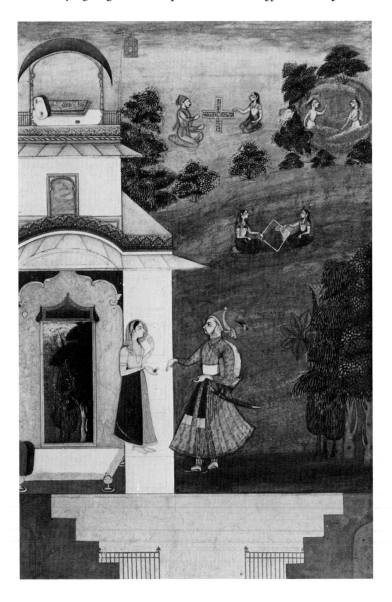

27
The month of Karttik. From a *Barahmasa* series of the twelve months
Attributed to Murad, Bikaner, c.1725
10 × 6¾ in (26.2 × 17.3 cm)
I.S. 32-1980

34

Singh of Jodhpur, who spent much of his life in the imperial service, chose to patronise work in a strongly Mughal style, as seen in an unfinished drawing of a durbar scene [plate 23]. However, in later painting at Jodhpur, as elsewhere, this influence became muted and indigenous linear rhythms and colour schemes reasserted themselves. Artists at the court of Kotah in particular brought a unique linear verve to animal subjects such as hunts and elephant fights [plate 24]. The tumultuous energy of the colliding beasts is evoked by fluid or densely swirling passages of line and dramatic distortions of anatomical form. This powerfully empathetic rendering can be contrasted with the flat decorativeness of the Jain painter's elephant [plate 2], or with the rich colour effect and strictly naturalistic modelling of the Deccani and Mughal examples [plates 17–18].

Even at the desert-locked court of Bikaner, where in the late 17th century migrant Muslim artist families had worked in a Mughal-derived style with some Deccani elements, Rajput conventions reappeared within one or two generations. A picture of the autumn month of Karttik, from a *Barahmasa* series illustrating the activities of noble lovers during the twelve months of the year [plate 27], displays a formalised composition, elongated figures and vague spatial relationships. A noble and lady stand before a pavilion with a bed-chamber; another bed is prepared on the roof. In the background a couple play at *chaupar*, men bathe and women draw auspicious *rangoli* patterns on the ground.

A later and more lyrical fusion of the ardent sentiments of Hindu devotional poetry with the polished 18th century Mughal style occurred at Kishangarh, whose ruler, Savant Singh (1748–57), was himself an accomplished poet. The love sports of Krishna and Radha were depicted in palace and lakeside settings similar to those of Kishangarh [plate 26], and may have been based on Savant Singh's love for a dancer at his court, with whom he eventually retired to the holy city of Brindaban. But the perilously mannered sweetness of the Kishangarh style soon turned to a cloying sentimentality.

The Ranas of Mewar, who had long been regarded as the premier ruling family and the custodians of Rajput honour, had been the last to capitulate to the Mughals. During the 17th century they continued their earlier traditions of manuscript illustration in a bright and forceful style modified by some Popular Mughal influence. But from the early 18th century the Udaipur artists' best work consisted of ambitious and original paintings of court life: portraits, durbars, processions, hunts, religious festivals and *zenana* scenes, often of unusually large size and full of anecdotal detail. Some of the better compositions made use of architectural settings adapted from the palace buildings at Udaipur [plate 25]. Individual portraits of the Mughal type, showing an isolated figure seated or standing in profile, were often wooden, but a curious study of an obese courtier in a striped pink pyjama has a keen satirical edge [plate 28].

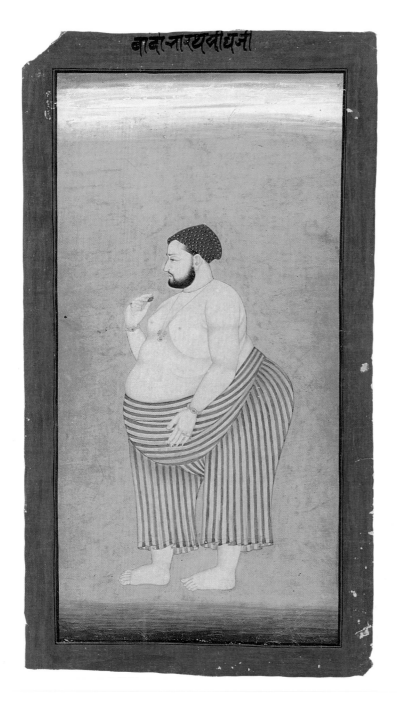

बाबानारथसीधजी

28
A nobleman, Baba Bharath Singh, in a state of undress
Udaipur, c.1740–50
15¼ × 7¾ in (38.7 × 20 cm)
Lent anonymously

29
A lady combing her hair
Jaipur, c.1790
14½ × 10½ in (36.6 × 26.5 cm)
I.S. 6-1955

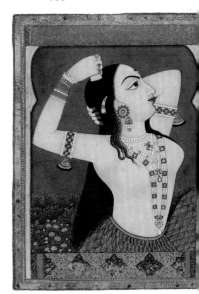

The dissolution of Mughal power in the 18th century was matched by a similar decline at the courts of Rajasthan. From the 1730s they were repeatedly overrun by the Marathas from the south, who brought about a political and economic chaos that lasted until the establishment of British suzerainty in 1818. Jaipur, which had been founded close to Amber by the distinguished astronomer Raja Sawai Jai Singh (1693–1743), is said to have reached depths of turpitude and intrigue exceptional even in an age of general decadence. But painting continued under its own inherent momentum. The Jaipur artists were much influenced by the hard contemporary style of Delhi and Lucknow. Even so, a hackneyed subject of a lady at her toilet [plate 29] could be transformed into a classically Rajput image by the accentuated outline drawing of the face and figure and the contrast of unmodelled flesh and background areas with the detail of jewellery, textile patterns and a flower garden. A more ebullient late phase of Rajasthani painting occurred at Kotah under Rao Ram Singh (1827–65), who is seen passing in procession through a bazaar [plate 30], entertained as he rides by a nautch girl supported on his elephant's tusks. If this picture lacks the kinetic force of the earlier elephant fight [plate 24], it still has much charm and panache. Already, however, a harsh synthetic green colour is in use. During the second half of the·19th century traditional painting either succumbed or was radically changed by the impact of Western techniques and the sensational art of photography.

30
Rao Ram Singh of Kotah riding
in procession
Kotah, c.1850
12¾ × 19¼ in (32.5 × 49 cm)
I.S. 564-1952

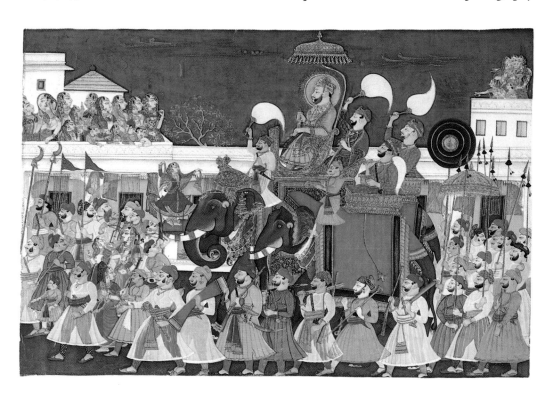

Rajput Painting in the Punjab Hills

Unlike the widely scattered courts of Rajasthan, the numerous minor Rajput kingdoms of the Himalayan foothills were clustered in an area only three hundred miles long by a hundred wide. Although they shared a similar cultural background to the southern Rajput courts, they were effectively separated from them by the broad expanse of the Punjab plains, and they were also less affected by Mughal incursions. This comparative isolation, together with the closer communications between the Hill courts, contributed to the

31
Raja Balwant Singh inspecting
the points of a horse
By Nainsukh, Jammu, c.1750
$9\frac{3}{4} \times 13\frac{1}{2}$ in (24.6 × 34.2 cm)
I.S. 8-1973

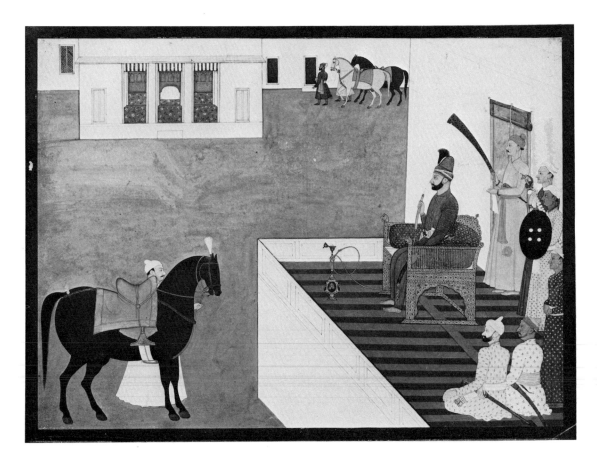

development of some of the most expressive styles of Indian painting, characterised in their earlier phases by a controlled vehemence of colour and line, and later by a mellifluous idiom that combined Mughal technique with Rajput devotional and romantic sensibility.

The origins of the first classic style of Pahari (Hill) painting, associated with the court of Basohli, are still not understood, though it may have had antecedents in the widespread pre-Mughal style [plates 4–5] as well as in local Hill idioms. An early illustration to the *Rasamanjari*, a poetical text classifying lovers and their behaviour [plate 32], reveals a fully formed and highly charged style, with a taut line and vibrant palette. The interpretation of literary conceits is as direct as in Rajasthani manuscripts. A lady who has been secretly unfaithful explains to her confidante that the love-marks on her breast were in fact scratches caused by the household cat as it chased a rat during the night. The cat and the rat appear on the pavilion roof. There is nothing here of the hybrid weakness sometimes found in Rajasthani work affected by Popular Mughal influence. So confident was the Pahari artists' vision that Mughal portraiture could be reinterpreted with equal intensity. The Mankot raja with a rosary, *huqqa* and sword [plate 34] is not a psychological study of an individual but a celebration of the proud Rajput type, silhouetted against a hot yellow background, orange bolster and white floorspread. Painting at the court of Kulu had a particular wildness and zest. *Kuntala raga*, from an extended *ragamala* series of the Pahari type [plate 33], is depicted as a prince feeding pigeons; Akbar himself had been fond of the sport of pigeon-flying, which was known as *ishq-bazi* or 'love-play'.

Although there is some evidence of strongly Mughal-influenced work in the Hills in the late 17th century, comparable to that of the Bikaner school, this was exceptional during the first phase of Pahari painting. But in the second quarter of the 18th century a fundamental change of direction took place. Artists trained in the Mughal style began to arrive in increasing numbers, particularly after the sack of Delhi in 1739. From being the vehicle of a jaded sensuality, their technique became revitalised in lyrical depictions of Hindu poetical and devotional subjects, in a development paralleled in Rajasthan by the less subtle Kishangarh style.

Members of the family of the artist Pandit Seu, who were based at Guler but travelled widely among the Hill courts, were influential in shaping and disseminating the new style. One of Seu's sons was the great portrait artist Nainsukh, who had probably received some Mughal training. He enjoyed an unusually intimate and understanding relationship with his patron, the minor prince Balwant Singh, whom he portrayed carrying out all the daily activities of a nobleman: hunting, listening to music, inspecting a horse [plate 31], or simply writing a letter or preparing to go to bed. Compared with the stark Mankot picture [plate 34], Nainsukh's portraiture and spatial setting are far more naturalistic. Nevertheless

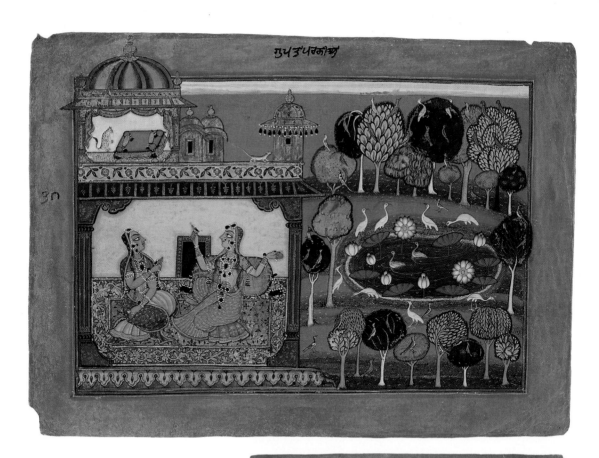

32
The cat and rat: a lady excuses
her love-bites as cat scratches.
An illustration to the *Rasamanjari*
of Bhanudatta
Basohli, c.1660–70
14½ × 10½ in (23.5 × 32.5 cm)
incl. border
I.S. 20-1958

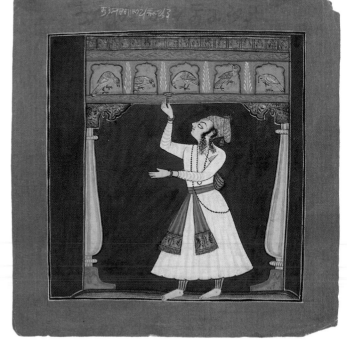

33
A prince feeding pigeons.
Illustration to the musical mode
Kuntala raga
Kulu, c.1700–10
6¼ × 6¼ in (16.2 × 16.2 cm)
excl. border
I.S. 73-1953

34
Raja Ajmat Dev smoking a
huqqa
Mankot, c.1730
10¼ × 7½ in (27 × 19 cm) incl.
border
I.S. 23-1974

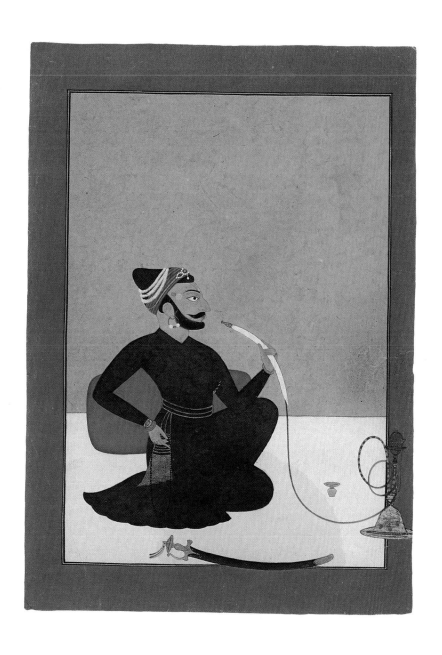

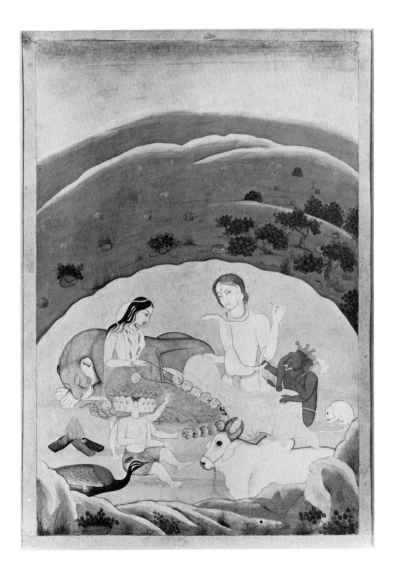

35
Shiva and his family on Mount
Kailasa
Guler, c.1745
10½ × 7¼ in (26.8 × 18.4 cm)
I.S. 11-1949

the bold, geometrical arrangement of the architecture and back-
ground areas remains typically Rajput.

A religious subject in the early Guler style [plate 35] combines the
new technical refinement with a devotional feeling taking the form
of tender domestic observation. Shiva is shown sewing a garment,
while Parvati strings human heads for his necklace. Their sons, the
many-headed Karttikeya and the elephant-headed Ganesha, who
plays with Shiva's cobra, sit beside them, and their respective
vehicles, the bull, lion, peacock and rat, wait in attendance. Versions
of the graceful Guler idiom were developed at several courts, such
as Garhwal to the south-east, where a *Barahmasa* illustration of the
winter month of Aghan was painted [plate 36]: a pair of lovers,

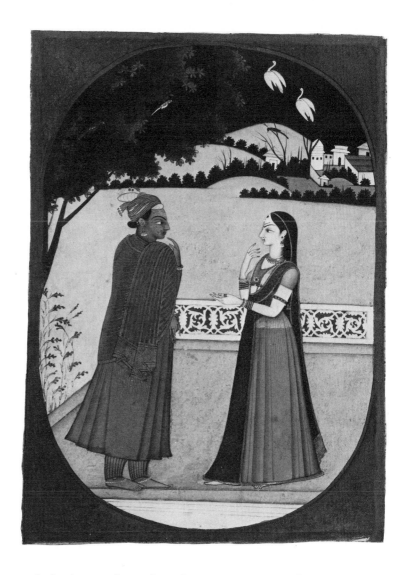

36
The month of Aghan, from a
Barahmasa series of the twelve
months
Garhwal, c.1780–90
7¼ × 5¼ in (18.5 × 13.2 cm)
I.S. 6-1960

idealised as Radha and Krishna, gaze at one another on a terrace while two cranes fly skywards.

The last great Pahari patron was Raja Sansar Chand of Kangra (1775–1823), whose long reign saw both the final maturity of Hill painting and the beginning of its decline. Early in his reign several masterly series of the classic texts celebrating the life of Krishna were illustrated for him. The love of Radha and Krishna was depicted with tender directness in idyllic landscape settings [plate 37]. As in earlier periods of Indian painting, the luxuriant burgeoning of nature serves to enhance and express the emotions of the human figures. Krishna is as usual shown as an elegant, princely figure, perhaps akin to the young Sansar Chand. As at Guler, scenes of *zenana* life

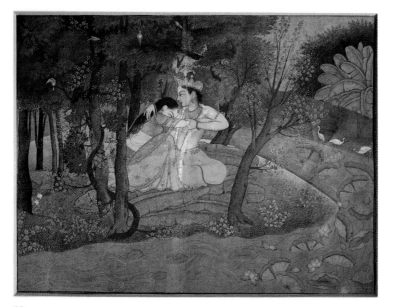

39 ▷
Maharaja Gulab Singh of Jammu
and Kashmir
Sikh style, Lahore, c.1846
$10\frac{1}{4} \times 8\frac{1}{4}$ in (26.2 × 20.7 cm)
I.S. 194-1951

37
Radha and Krishna in a grove
Kangra, c.1780
$5\frac{1}{4} \times 7$ in (13 × 17.5 cm)
I.S. 15-1949

38
Ladies celebrating the Holi
festival
Kangra, 1789
$5\frac{1}{2} \times 9\frac{1}{2}$ in (14 × 23.5 cm)
I.S. 9-1949

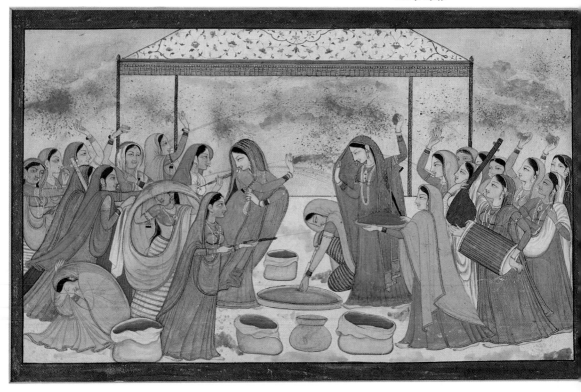

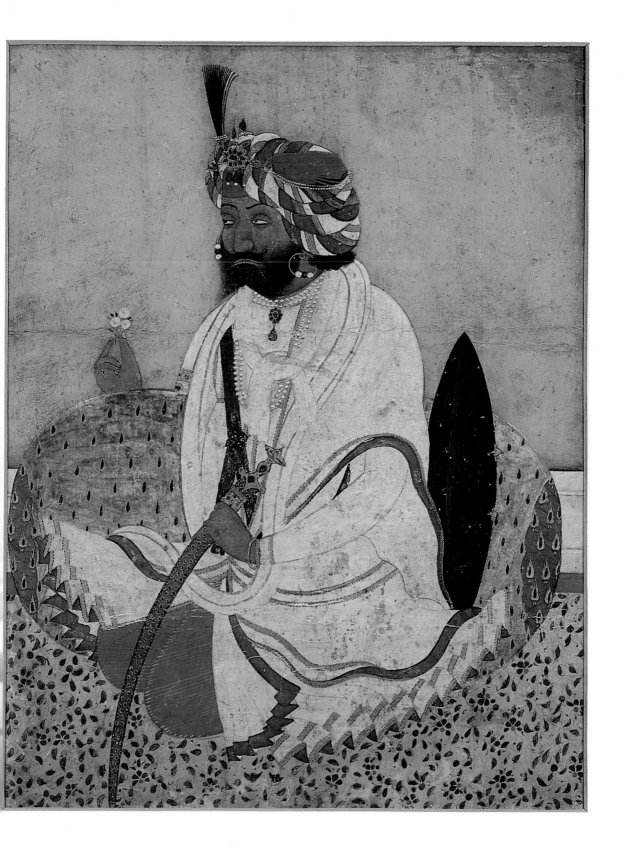

were also charmingly rendered, with increasingly curvilinear rhythms, as in a scene of ladies throwing powder and squirting water at the spring festival of Holi [plate 38]. But, as at Kishangarh, such a sweetly refined style could only remain fresh for a short time. From the beginning of the 19th century it became facile and sentimental. At the same time, Sansar Chand's power was lost first to Gurkha invaders and then to the Sikhs, who had won control of the Punjab plains and now began to annexe the Hill kingdoms. However, the British traveller William Moorcroft, who visited Sansar Chand in 1820, reports that, though living in reduced circumstances, he was still 'fond of drawing' and continued to support several artists as well as a *zenana* of three hundred ladies. His daily life was still passed in an orderly round of prayer, conversation, chess, viewing pictures and performances of music and dance.

The Sikhs continued to hold the Punjab until their displacement by the British in 1849. They commissioned portraits of their Gurus and themselves in a weakened Pahari manner, to which they brought little inspiration as patrons. However, one of the most imposing of all Indian portraits is that of Maharaja Gulab Singh [plate 39]. His large figure, which fills the picture area, is shown seated, holding the familiar props of a sprig of flowers and a sword. He wears a dextrously composed turban and coat with sharply ruffled hem, and his face, no longer in profile, stares obliquely away from the viewer in baleful self-possession.

Further Reading

Although a huge number of Indian paintings have now come to light, particularly in the last thirty years, only a small part of this material has yet been methodically studied. Mughal painting, being relatively well documented and accessible in public collections, is best known. Certain areas, including most of the Rajasthani schools, have been only superficially explored. In this primitive but gradually advancing state of knowledge, no general survey or introduction can be entirely dependable, and publications over thirty years old are likely to be out of date in varying degrees. Many of the more recent publications are in the form of exhibition catalogues. These often provide concise and helpful introductions to their subjects as well as further bibliography, including references to the articles in periodicals which form a large part of the literature.

The best general survey is still Douglas Barrett and Basil Gray, *Painting of India*, Geneva, 1963, reprinted as *Indian painting*, London, 1978. Jeremiah P. Losty, *The Art of the Book in India*, London, 1982, is a valuable survey of the history of manuscript illustration. W. G. Archer, *Indian Miniatures*, London, 1960, contains 100 plates with commentary. Philip Rawson's interesting *Indian Painting*, Paris and New York, 1961, and Jamila Brijbhushan's more elementary *The World of Indian miniatures*, Tokyo, 1979, are of use, but both contain errors. Two exhibition catalogues by Stuart Cary Welch, *A Flower from Every Meadow*, New York, 1973, and *Indian Drawings and Painted Sketches*, New York, 1976, include pictures of all types with illuminating commentary.

An attractive and inexpensive introduction to the Mughal school is Stuart Cary Welch, *Imperial Mughal Painting*, London and New York, 1978; Percy Brown, *Indian Painting Under the Mughals*, Oxford, 1924, reprinted New York, 1975, is also still useful. Two catalogues by Milo Cleveland Beach, *The Grand Mogul: Imperial Painting in India 1600–1660*, Williamstown, 1978, and *The Imperial Image: Paintings for the Mughal Court*, Washington, 1981, survey the first hundred years of Mughal painting. Pramod Chandra, *The Tuti-Nama of the Cleveland Museum of Art and the Origins of Mughal painting*, Graz, 1976, is an important scholarly study. Bamber Gascoigne, *The Great Moghuls*, London, 1971, is an excellent, well illustrated historical introduction.

The main books on the Deccani schools are Douglas Barrett, *Painting of the Deccan, XVI–XVII century*, London, 1958, and the more comprehensive *Deccani Painting* by Mark Zebrowski, London, 1983. Edwin Binney 3rd, *Indian Miniature Painting from the Collection of Edwin Binney 3rd: the Mughal and Deccani schools*, Portland, Oregon, 1973, is useful. Toby Falk and Mildred Archer, *Indian Miniatures in the India Office Library*, London, 1981, contains much Mughal and Deccani material, particularly from the later periods.

In the field of Rajput painting, the Pahari schools have so far received most study. W. G. Archer, *Indian Paintings from the Punjab Hills*, 2 vols, London, 1973, is and indispensable survey, complemented by F. S. Aijazuddin, *Pahari Paintings and Sikh Portraits in the Lahore Museum*, London, 1977. Other titles by W. G. Archer include *Paintings of the Sikhs*, London, 1966, *Visions of Courtly India*, Washington, 1976, and *The Loves of Krishna*, London, 1957, a useful introduction to Krishna in myth and painting, as are Francis G. Hutchins, *Young Krishna*, West Franklin, New Hampshire, 1980, and A. Dallapiccola and E. Isacco eds., *Krishna, the Divine Lover*, London, 1982. A. K. Coomaraswamy's pioneering work, *Rajput Painting*, 2 vols, London, 1916, is still worth reading. Klaus Ebeling, *Ragamala Painting*, Basel, 1973, and Ernst and Rose Leonore Waldschmidt, *Miniatures of Musical Inspiration*, 2 vols, Bombay, 1967 and Berlin, 1975, are thorough studies of *ragamala*. M. S. Randhawa, *Kangra Paintings on Love*, New Delhi, 1962, is a well illustrated guide to the poetical typology of lovers.

Exhibition catalogues dealing with both Rajasthani

and Pahari painting include: Robert Skelton, *Indian Miniatures from the XVth to XIXth centuries*, Venice, 1961; Stuart Cary Welch and Milo Cleveland Beach, *Gods, Thrones and Peacocks*, New York, 1965; Edwin Binney 3rd and W. G. Archer, *Rajput miniatures from the collection of Edwin Binney 3rd*, Portland, Oregon, 1968. Karl Khandalavala, Moti Chandra and Pramod Chandra, *Miniature Paintings from the Sri Motichand Khajanchi Collection*, New Delhi, 1960, and Andrew Topsfield, *Paintings from Rajasthan in the National Gallery of Victoria*, Melbourne, 1980, deal mainly with the Rajasthani schools. Also relevant are Moti Chandra, *Jain Miniature Paintings from Western India*, Ahmedabad, 1949; W. G. Archer, *Indian Painting in Bundi and Kotah*, London, 1959; Milo Cleveland Beach, *Rajput painting at Bundi and Kota*, Ascona, 1974.